T0195893

THE TATTOO APPRENTICE GUIDE FOR BRINGING PRISON INK TO THE STREETS

Bo Dean

authorHOUSE®

AuthorHouse™
1663 Liberty Drive
Bloomington, IN 47403
www.authorhouse.com
Phone: 1 (800) 839-8640

Published by AuthorHouse 01/29/2020

ISBN: 978-1-7283-4061-6 (sc)
ISBN: 978-1-7283-4060-9 (e)

Library of Congress Control Number: 2019921238

Print information available on the last page.

This book is printed on acid-free paper.

CONTENTS

INTRODUCTION

The fact that you picked this book up means that you are either interested in learning how to tattoo like a prison artist, or perhaps just simply interested in the mechanics of prison tattooing. This book is not a replacement for practical training, but a resource for you to use to add new methods and techniques to your skillset and to supply you with the tricks of the trade that prison tattoo artists have taken years to develop.

In the past, anyone with prison tattoo art was easily identified as someone who had been previously incarcerated. Over several million people have cycled through the state and federal prison system over the past numerous years. Having prison ink doesn't carry the same stigma within society it used to. Also, most prison tattoo art is very well put together.

Prisoners have nothing but time on their hands – and for prison tattoo artist that means time to study layouts, methods, styles, and shading techniques. The art themes for tattoos are carefully planned and then critiqued by other prisoners.

The good news is, you don't have to go to prison to learn how to sling ink like a prison pro. That's where this book comes in. Inside these pages you'll learn how to build your own prison-style tattoo gun, how to make your own ink, and we'll cover the many tips and tricks that'll have you tattooing just like a prison pro.

CHAPTER 1

How to Build a Tattoo Gun from Practically Nothing

Before you begin tattooing, or as Benny the Bad Guy calls it, "Slangin and Bangin," you're going to need a tattoo gun. A properly working gun is fundamental to the entire process. Using a faulty gun can cause no end of trouble and can ruin a tattoo. Sure, you could go out and spend hundreds or thousands of dollars and buy yourself a tattoo gun, but why do that if you don't have to?

This Chapter will teach you how to build a hardcore prison tattoo gun that will not only be reliable, but will also look cool – at little to no cost. Other tattoo artists will be amazed when they see your tattoo gun made from practically nothing and your clients will know they are getting the real deal.

The first thing in getting started is to locate an old electric motor. One can be purchased from a secondhand store for under ten dollars, or you can save yourself from some money and scavange one up from around the house.

An electric motor can be found in all sorts of old things that are waiting to be tossed out: toy cars, VCR/DVD players, hair trimmers, CD – ROMs, tape players, an electric toothbrush, and various other small electronics that have little to no value. You'll be surprised how many common household items have these small electric motors as components. Illustration **1a** shows the three most common motors found in home electronics.

Jolly Rancher Style Standard Style Pancake Style

ILLUSTRATION 1A

Use caution when disassembling an electronic device. Before you begin, double check that the device has been disconnected from all power sources and the batteries have been removed. Most devices have sharp edges, so use gloves to protect your hands.

Once the electric motor has been removed, the plastic motor housing surrounding the motor can be discarded. You will also need two lengths of thin, 24-gauge wire, around 3-foot in length each. The wire doesn't have to be new, but it must be damage free to prevent accidental loss of power. Wires that are damaged or worn can cause complications with the tattoo gun and can lead to imperfections in the tattoo. Attach the wires to the motor by soldering them directly to the terminal posts located on the back.

Be sure to fasten the wires securely to the posts. Loose connections are common fail point in power delivery.

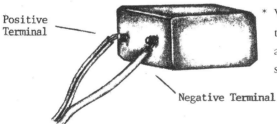

Positive Terminal

Negative Terminal

* When connected properly to the power source, the armature of the motor should spin counter-clockwise.

ILLUSTRATION 1B

Once the wires are securely fastened to the terminal posts, use a (AA) battery to test the connections. If the motor spins clockwise, reverse the battery and try again. To prevent problems with the motor, it is important the armature spins only in the counter-clockwise direction.

Once the connections have been tested and the motor is working properly, you're ready to prepare the offset for the tattoo gun. The offset is a critical part—not only is it used to attach the tattoo needle to the motor, but it also controls the penetration depth as well. A faulty offset will cause the tattoo gun to malfunction and keep the skin from holding ink. Everything needs to have a tight fit! It is not always evident that the offset is the cause of the problem and can lead to many painful hours of guesswork. Always check the offset for inevitable wear and tear.

A quick and easy offset can be made from an ink pen insert tube from a ballpoint pen. To begin, remove the ink tube from the body of the pen. Once the tube is removed, separate the head (the part that contains the ballpoint) from the ink tube. Run the ink tube under warm water for several minutes to flush any residual ink. When finished, the empty tube should resemble the Empty Insert shown in Illustration **1C**.

Set the head of the pen aside for later. It will be used as a guide for the tattoo needle.

Heat the tip of the empty insert with a small flame for a few seconds, just until the tube starts to melt, then quickly press the tube down on a hard, flat surface so the tip flares out into a saucer shape about a quarter-inch to half-inch in diameter. It may take several tries to get this technique down.

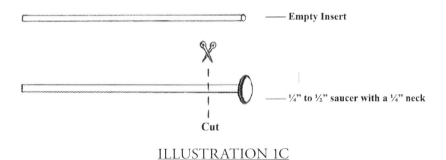

——— Empty Insert

——— ¼" to ½" saucer with a ¼" neck

Cut

ILLUSTRATION 1C

Once the tube has cooled down and hardened, cut the saucer from the tube leaving a one-quarter inch neck attached to the saucer, as shown in Illustration **1C**. Now you have an offset that can easily be attached to the armature of the motor. The offset should have a snug, tight fit. If it does not, try a different style of ink pen with a narrower or wider insert tube.

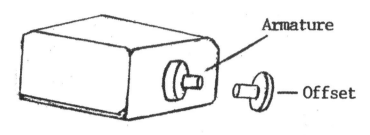

ILLUSTRATION 1D

If you are comfortable with the offset that you have made you will need to create a needle pocket, as shown in Illustration **1E**. The needle pocket will allow the tattoo needle to be easily fastened to the offset. To create a needle pocket, heat the end of a sewing needle and then quickly pierce the offset about an eight-inch from the edge. Make the hole just wide enough that the tattoo needle has a snug fit. Multiple needle pockets can be made on a single offset.

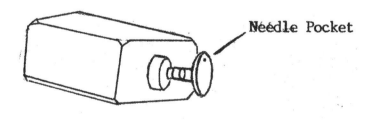

ILLUSTRATION 1E

The next piece that needs built is the mount. The mount supports the motor and provides a cradle for the barrel, which holds the needle in place.

You will need a flat, hard pierce of plastic of about a half-inch thickness, cut to 2 ½ inches in length and no wider than the motor. In Illustration **1F** a flat toothbrush handle was used. The surface of the mount must be flat and level to keep the motor secure and aligned.

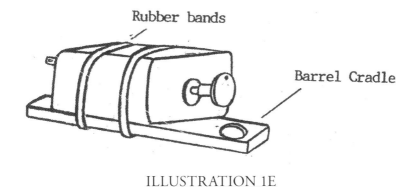

ILLUSTRATION 1E

After the amount is cut to the appropriate size, a hole will need to be bored into the mount a half-inch from one of the ends, centered. The size of the hole should barely be big enough for the ink pen's barrel to fit-- the barrel should have to be forced into the barrel cradle to prevent it from moving during a tattoo. Place the electric motor on top of the mount as shown in Illustration **1F** and, using a couple of small rubber bands, fasten the motor securely to the mount. Now it's time to prepare the barrel that will keep the tattoo needle in place. The barrel is a disposable attachment of the tattoo gun and has to be replaced after each client to prevent the spread of disease and bacterial infections. Get used to making these! You will need a fresh one each time you tattoo.

The length of the barrel is dependent upon the needle stock that you choose to use. A common needle stock used in prison is a guitar string cut to 2 1/2 inches in length. The barrel should be cut with a utility knife, approximately 1/2 of an inch to 5/8 of an inch, shorter than the needle, as shown in Illustration **1G**.

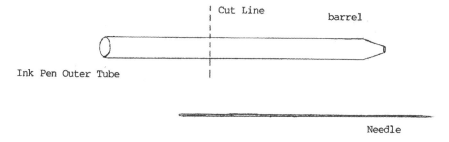

ILLUSTRATION 1G

Next, use a pair of toenail clippers and snip the tip, about 1/32 of an inch, off the head of the ballpoint. The opening should be just big enough to allow the needle to pass through freely, up and down, without any interference or derailment. If needed, flush the ballpoint head out with warm water to remove any remaining ink and debris.

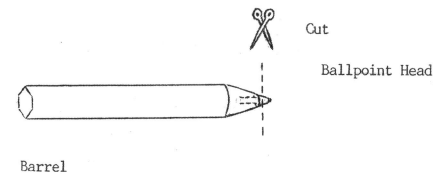

ILLUSTRATION 1H

Take the left-over insert tube, the part of the pen used to make the Offset, and insert it back into the head of the ballpoint. Once the insert is in place, cut the insert about a half-inch from the head, creating the ink reservoir shown in Illustration **1I.**

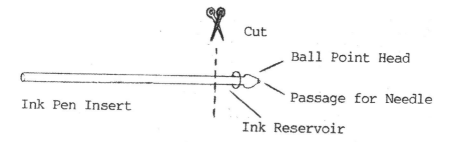

Cut

Ball Point Head

Ink Pen Insert

Passage for Needle

Ink Reservoir

ILLUSTRATION 1I

Next, using toenail clippers or a set of pliers, bend the needle stock about a half- inch from the end to a 90° angle, creating a hook that will allow the needle to be fastened to the Offset. The needle must be sharpened before each use. How to do this is covered in a later Chapter. Now it's time to assemble all of the pieces, as shown in Illustration **1J**.

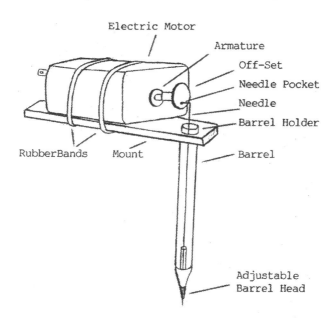

Electric Motor

Armature

Off-Set

Needle Pocket

Needle

Barrel Holder

RubberBands

Mount

Barrel

Adjustable
Barrel Head

ILLUSTRATION 1J

CHAPTER 2

Making the Power Supply

Now that your tattoo gun is assembled and ready for use, it will need a power supply that is sufficient enough to operate it correctly. To do this, you will need to know how many volts the electric motor requires.

If the device you pulled your motor from was battery operated, then it's however many batteries the device used. For example, if you pulled your motor from a pair of beard trimmers that ran on two (AA) batteries, then you would make your battery pack using two (AA) batteries.

Battery packs can be made from an endless variety of materials. What is important is that the materials used, and the pack's construction, gives a reliable, secure connection resulting in a constant powerflow. The last thing you want is for your tattoo gun to slow down or rev in the middle of a tattoo all because of a faulty connection.

The battery pack in this chapter is made out of common items: A toggle switch, copy paper, packing tape, and a few razor blades removed from disposable razors, and will use two (AA) batteries.

To begin, take the two batteries and line them up side by side. Next, cut a piece of copy paper to where the measurements are equal to three times the width, and two times the height, of the two batteries. Wrap the two batteries in the cut piece of copy paper, nice and tight, then secure it all with packing tape. The batteries should now be snug within the paper.

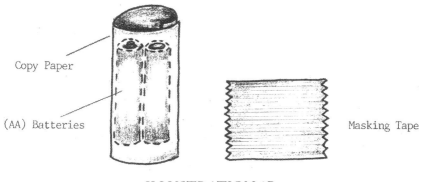

Copy Paper

(AA) Batteries

Masking Tape

ILLUSTRATION 2B

Once that is accomplished, it's time to cut the flaps that will be used to form the top and bottom enclosures of the battery pack. The bottom enclosure is relatively simple. Instructions are given in Illustration **2B**.

Cut flaps, fold, and secure with packing tape.

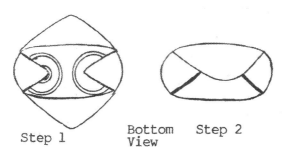

Step 1

Bottom View

Step 2

ILLUSTRATION 2B

The top enclosure is a bit more elaborate. Illustration 2C shows step-by-step the different stages of construction.

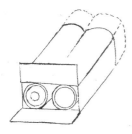

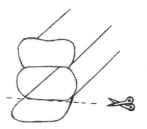

Step 1: Cut out the sides of the excess paper, creating two flaps.

Step 2: Cut off the bottom flap, leaving only the top.

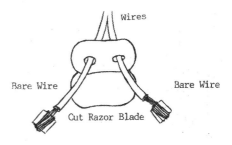

Step 3: Punch two holes in the upper flap large enough for the wires to go through. Center each hole over a battery.

Step 4: Run a wire through each hole in the flap. Cut two quarter-inch pieces off of a razor blade, and then expose enough bare wire to securely wrap each blade.

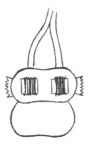

Cut Line

Step 5: Pull the makeshift connections back flush against the flap. Secure everything in place with a piece of tape on the backside of the flap, securing the wires at the same time.

Step 6: Take one of the disposable razors and cut it a hair longer than the width of the battery pack. This will ensure a tight fit.

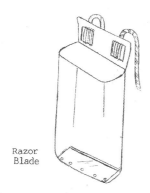

Razor
Blade

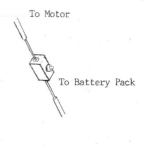

To Motor

To Battery Pack

Step 7: Place the razor blade inside of the battery pack, wedging it in place so that it fits snugly at the bottom.

Step 8: The last piece needed to complete the battery pack is the toggle switch. Splice the toggle into the negative line, near the gun itself for accessibility.

Step 9: Place the batteries into the battery pack. Make sure the batteries are placed the correct way.

ILLUSTRATION 2C

After you have finished assembling the battery pack place a few rubber bands around it, top to bottom, to secure the top flap and keep the connections properly fastened.

At this point, your tattoo gun should be fully assembled· and look something like the one shown in Illustration **2D**.

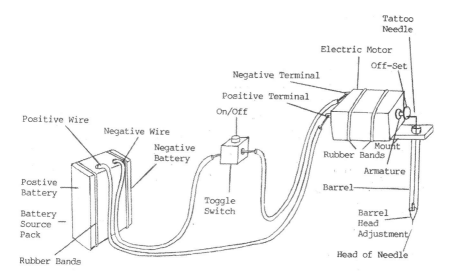

ILLUSTRATION 2D

If everything looks good to go, it's time for a test run. Turn on the toggle switch. The gun should be running smoothly. If the needle is rubbing against the barrel, the rubber bands that secure the electric motor to the mount make adjustments easy. Simply move the motor forward or backward until the needle can move freely. If the motor does not turn on, check all your connections and make sure you are using fresh batteries. Once everything is running properly, your assembly is complete and you are ready to move on to the next chapter.

CHAPTER 3

Tattoo Needle Options

The best type of needle any professional tattoo artist could use would be one that has been precision sharpened by a machine designed for manufacturing needles. Unfortunately, in prison, tattoo artists are unable to get access to these types of needles. This leaves us with making our own.

Safety is the first priority in the tattoo industry. The same goes for getting a prison tattoo. The biggest concern is getting needles that are clean and have never been used. Most tattoo artists prefer to get their own stock and make their needles themselves, for the safety of the customer. For safety purposes, every customer must receive their own needle and barrel assembly.

A variety of materials can be used to make good needles. Guitar strings are a common stock used in prison, and they can be cut to the desired length. The preferable length to cut the stock is an inch longer than the barrel. This will compensate for the 90° bend at the end where the needle attaches to the offset.

To sharpen the needle you will need a fine grade of sandpaper, at least 240 grit, cut to about 3-inches square. An eraser head from a Number 2 pencil will also be needed. Pierce the eraser with the needle stock, going through an inch and a half to the other side, as shown in Illustration **3A**. Using two fingers, roll the needle back and- forth across the grain of the sandpaper. Sharpen the needle head until it takes the shape of a torpedo.

ILLUSTRATION 3A

There are a couple of methods that can be used to determine that the needle is sharpened and ready to use.

The first method is called the "Prick Test" and should only be done on the person the needle is intended for to prevent contamination. Take the needle and softly prick the pad of the person's index finger. The needle should pierce the skin easily and hang upside down without falling out.

The other method is to look at the needle under a magnifying glass. The head of the needle should come to a complete point, and its shoulders should be even. Done properly, the needle will easily pierce the skin and the ink will properly flow into the tattoo. If one shoulder is lower, or higher and longer, it could result in poor penetration and improper ink flow.

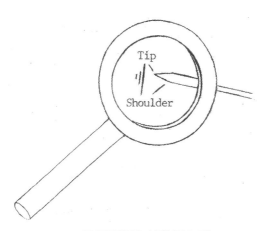

ILLUSTRATION 3B

CHAPTER 4

Making Your Own Ink

Making your own tattoo ink can save you hundreds of dollars versus purchasing conventional ink. With enough time and practice, your homemade ink will be on par with the more expensive commercial ink.

Making your own ink can be a little bit messy and somewhat time consuming. There isn't a precise recipe for preparing ink, so you will have to learn a few important tricks of the trade. Once mastered, you will be able to achieve the consistency and quality that you'll need.

The first thing needed to make a high quality ink is a nice batch of soot, a major component of tattoo ink. Anywhere an enclosed fire's been, you'll find soot. Using fresh materials in making your ink is essential in minimizing exposure to bacteria which can potentially be harmful to the skin.

Here is a list of materials you will need:

- An empty 12-Pack soda can box
- An empty pop can
- A jar of vase line
- Masking tape
- Scissors
- Shampoo
- Rubbing Alcohol
- A sheet of newspaper
- A cigarette lighter
- Toilet paper

- A brown bag
- Instant coffee
- An empty 4oz. bottle with a cap, cleaned thoroughly
- A quarter-inch lug nut

Take the empty soda can and cut the top-half off.

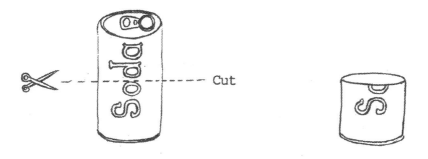

ILLUSTRATION 4A

Fill the bottom half of the can with the vaseline. Next, roll three to four squares of toilet paper to form a half-inch thick wick. Push the wick into the can of vaseline, centered, standing vertically. The bottom of the wick should touch the bottom of the can. Saturate the exposed part of the wick with additional vaseline for a slow, even burn.

Open both ends of the sode box. Expand open the brown, paper bag and push one end of the soda box into it about two inches. Tape the bag to the box. Be sure to create a good seal to prevent soot from escaping.

After attaching the bag securely, search the box and bag for any small holes that would let the soot escape. Use the tape to seal any leaks.

Now it's time to find a well ventilated area that's away from other flammable materials. The location should be one where there will not be any children or pets present. Safety here is paramount; any area with flammable flooring (carpet, hardwood, linoleum, etc.) or where gas cans are present is not safe.

Once a location has been selected, place a sheet of old newspaper on the floor to catch any debris. Place the can in the middle of the newspaper and light the wick. Your setup should look similar to Illustration **4B.**

Let the makeshift candle burn for about a minute, then place the box over the can with the can centered in the middle of the box. Wet toilet paper can be placed around the bottom of the box to form a seal. This will help trap the soot in the box and bag. The makeshift candle should burn for about four to six hours, depending on the flame of the wick.

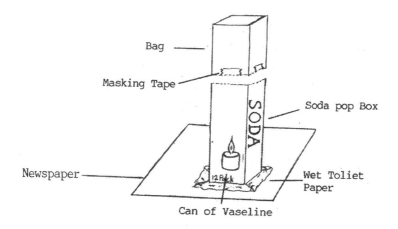

Bag

Masking Tape

Soda pop Box

SODA

Newspaper

Wet Toliet Paper

Can of Vaseline

ILLUSTRATION 4B

Let the candle burn until all of the vaseline is gone. When the candle is finished burning, remove the box and discard the can. Take a pair of scissors and starting at the open end of the box, cut a straight line all the way to the end of the bag, laying it all open. After the box and bag are cut open, use an ID card or credit card to scrape out the soot. It should come off fairly easily. Do this over the newspaper to keep from losing any of the soot. Once you have all of the soot scraped off onto the newspaper, funnel it into the four-ounce bottle, filling the bottle up as much as possible. Put a few drops of rubbing Alcohol in the bottle to help remove any impurities that may be in the soot, and a half-teaspoon of instant coffee to aid in the soot's breakdown.

Drop the quarter-inch lug not into the bottle. This will be used as a "clacker", similar to what you would find in a spray paint can. The clacker will aid in the breakdown of the soot, promoting consistency. Place the cap onto the bottle and shake the contents for a few minutes to mix thoroughly. Place a small drop of quality shampoo along with two to three drops of

water inside the bottle. The amount of water needed will vary depending on the amount of soot acquired from the burning. Shake the contents of the bottle for several more minutes.

Add more water as needed but keep the ink thick, to where it slowly pours from the bottle. By keeping the ink thick, you can later dilute it as needed while tattooing. With experience, you will learn to find the ideal consistency of perfect ink. When you are finished making the ink, let it sit for twenty-four hours before use. Shake the ink periodically to promote the breakdown of the soot.

After twenty-four hours has passed, it's time for the clump test. Shake the bottle well for several minutes. Open the bottle and dump a small droplet of ink into a toilet. If the ink clumps together without separating, it has passed the first test. If the ink streams apart and turns the water grey, then the soot hasn't completely broke down and the ink should be allowed to sit another twelve to twenty-four hours. Shake Periodically.

If your ink has passed the clump test, it's time for the skin test. Using your tattoo gun, make a small dot into the skin using the new ink. If the spot is nice and dark, the ink is penetrating underneath the skin and is ready to use.

CHAPTER 5

Training and Preparation

Now that you have your prison style tattoo gun and homemade ink, you'll need to learn how to assemble/disassemble your gun like a pro. It would be very unprofessional if you had trouble assembling your equipment, especially in front of a client. With a little bit of practice you'll get the hang of assembling your gun in a confident, hassle-free manner and give your client a sense of hope that you at least have a clue to what is going on before you start the actual tattoo.

The next step in preparation requires a willing partner to assist you. Once you have someone, have that person place themself in different positions as if you were going to tattoo them in those positions. This will give you a heads up on what works for you and what doesn't. Placing your client in a comfortable position is a must, especially if the client is to remain in that position for a substantial amount of time.

Performing a tattoo can take anywhere from several minutes to several hours. The position you place your client in must not undermine the position that you, as an artist, must take to perform the tattoo work. Poor positioning can affect the quality of your line work, thus resulting in a lower quality tattoo.

Assessing the lighting situation is a must before getting started. You will need adequate lighting to see by and have it positioned correctly so your hand will not cast a shadow across where the tattoo is going. Portable lights are great because they are so easy to adjust.

As a safety precaution you'll need to place protective covers around the tattoo gun and cord. This will help keep contaminants from coming

in contact with your equipment. Protective covers can easily be made with plastic wrap and scotch tape.

Another safety precaution you'll need to observe is in using disposable ink containers that are filled while performing the tattoo. These containers can only be used on one client. Once a container has been used, it is considered contaminated and should never be reused. Also, any remaining ink in these containers should be disposed of and never returned to the ink bottle.

You'll want to have a disposable container of vitamin A&D ointment on the same tray you have your ink. The ointment will be used throughout the tattoo and should be readily available. The last thing you'll want to have on hand are some disposable rags. They are cheap and can be bought in large quantities. Always dispose of them. Your clients will feel better if you use a new rag versus a used one that has been washed.

All of these tips will help you properly prepare for your client and give your client the safety they deserve.

CHAPTER 6

The Mechanics of Tattooing

It's important, in order to get good end results, to learn the mechanics of tattooing. Your mastery of these mechanics will either make you or break you in the industry.

The first thing you should know is that the tattoo gun will do all the work for you. The function of the gun is to penetrate through several layers of skin with the needle. It is essential your gun is assembled correctly. Replace parts that are worn out, such as an offset with a bad or loose needle pocket. Replace the batteries after four to six hours of use. Keep these things in mind to prevent problems mid-tattoo.

The second thing to learn is the proper angle to hold your gun at. A 45° angle works best, allowing the ink to flow properly under the skin's surface. If the gun is held at a horizontal position you risk missing the lines of the pattern resulting in a poor quality tattoo.

The third thing to learn is the proper depth at which the needle should penetrate the skin. The needle should penetrate to approximately the width of a dime. Use this knowledge to your advantage. This depth will make good lines. Going deeper will cause your client tremendous pain and cause the ink to spread and shift. Going too shallow will result in a very light color, which may be suitable in some instances such as with shade work. Be aware of your needle depth, and use the head of the barrel to adjust the penetration level.

The fourth thing to learn is to have a proper stroke. Balance and control your stroke by using small movements. Take your time, nothing about tattooing is fast. Make sure whichever arm's holding the tattoo gun

has support, which will help in controlling the movement of the gun. Start a line at one end and finish at the other end without stopping. Try not to start in the middle of a line.

The last, but perhaps most important thing is to stretch the skin you're tattooing on with your free hand. If you forget to do this, your lines will look poor, the whole tattoo will look sloppy, and your client will be unsatisfied.

Practice these things until you are confident in your skill, Asking other, skilled tattoo artists for advice is always recommended, as long as they are reputable artists.

CHAPTER 7

Getting Ready for Your Clients

Preparation is an essential part of tattooing. Client health and safety are a primary concern. Always have anti-bacterial *soap* available for your client to wash the target area for where the tattoo is going. Wash your hands thoroughly, up through the forearms, and use a soft brush to scrub under your nails. Use a disposable towel to dry off with.

Gloves should be worn before handling the equipment. After putting on a pair of gloves, assemble your tattoo gun in front of the client to reassure them that the needles and barrel tubes are new and sterile.

Your work area should be exceptionally clean. Equipment should be sterilized via autoclave and have protective barriers separating it from the work station. Rugs and carpets should be prohibited in the work area if possible.

Once the client is situated, use a disposable razor to remove hair from where the tattoo will be going. Wash the area again with an antiseptic solution.

Always wear clean attire. Short sleeves are a must. Avoid wearing anything loose or baggy or any type of clothing that could accidentally come into contact with the tattoo.

Your client depends on you to ensure their safety. When a client comes to you for a tattoo, they are literally putting their health in your hands. Cleanliness is not optional, but a must.

CHAPTER 8

Tattoo Planning and Preparation

There are some questions that should be asked before you perform any work on a client.

- What type of design does the client want?
- Is the art lay-out appropriate for the location the client wants the tattoo placed in?
- How long will the tattoo take from start to finish?
- How much will the tattoo cost?
- Are you, the artist, comfortable with the design and location of the tattoo?

Once these questions are settled, it's time to prepare the design and stencil. The size of the design and placement can affect other tattoos the client may want in the future. Careful planning is a must. Once the design is complete, it'll need to be sized to fit the area where the tattoo will be placed. Pre-made patterns and stencils can be of great help when putting a tattoo together.

Some artists prefer to draw directly onto the body, but to do this you must be a very skilled artist and have an eye for shading. The best way to prevent mistakes is to use a stencil, this way any misspellings or other errors can be corrected before they become permanent.

Stencils can be made by using a thermo fax machine and carbon copy paper. Art patterns can be traced out onto tracing paper. This should be done with a pen using dark, bold outlines.

Once the pattern is traced out, cut and trim any excess paper out from around the pattern. This will make it much easier to place it on the client. Wipe an alcohol based deodorant over the area where the traced design will be placed. Put several applications on the skin to ensure good coverage. Apply the design, ink side down, to the skin. Run the deodorant down the back of the design to smooth out the tracing paper. Let the design sit against the skin for at least forty-five seconds to ensure proper transfer.

Once the paper is removed from the skin, you will have temporary lines to use as a blueprint to follow. Inspect the design carefully, this is your last chance to make sure that everything is placed and positioned correctly. Check over any words for misspellings. Allow the transfer to completely dry before moving forward with the tattoo process.

Once the transfer dries, study the pattern carefully making sure you can make out all the lines. If any appear too weak or too light, use a pen and fill in the trouble spots. Do not be afraid to restart the process if you or your client is unhappy with the design or its placement. Rework or reposition the design until everyone is satisfied.

After the client has agreed to move forward with the tattoo, it's time to position the client. Make sure your client understands that positioning is an important part of the process. If the tattoo is going to take a considerable amount of time to do, then either plan for rest breaks or do the tattoo across sessions. Typically, two to three hours will make up a session.

CHAPTER 9

Starting the Tattoo

Now that you are ready to start the actual tattoo, confirm that your client is in a comfortable position. After you begin the tattooing process, periodically check that the client is doing okay. If the client is jumpy, shakey, or moving around in pain the quality of the tattoo will suffer. You'll need to prepare yourself for these sudden moves. Get to know the areas of the body that are especially sensitive to better anticipate the chances of this happening. Straight, clean lines are the key to a sharp looking tattoo.

Always start by powering on the tattoo gun. Dip the needle into the ink until the head of the barrel is submerged. Let the gun run for a few seconds, letting it draw ink into the barrel.

Using your free hand, stretch the area of skin pulling it tight. This is a crucial part of the process. It is extremely important to keep the skin tight while tattooing, otherwise your lines will be blurry or in the wrong place.

Always start at the bottom of the design and work your way up. Follow the lines from one end to the other, moving slowly. Keep the skin tight. Dip your needle to refill the ink after each line is completed. If possible, avoid starting in the middle of a line. Keep in mind that the gun may occasionally spray ink and that your client will bleed. If the area becomes too messy to see the pattern, gently blot the area with a towel. Using a wiping motion can erase the lines from the transfer.

Once all the lines have been inked, check over the tattoo to make sure you haven't missed any by mistake. Once you have confirmed that all of

the lines have been filled in, use a warm, clean towel to wipe the area clean. Examine your work carefully and note any areas that need touched up.

When touching up a tattoo, follow the "three strike" rule. Do not tattoo the same line more than three times. Doing so can traumatize the skin, which can lead to scarring. Always use the three strike rule as a safety precaution.

After the line work is complete, its time to begin the shading process. Rub A & D ointment over the area to be shaded. This will act as a lubricant as excess ink is continuously wiped away with a towel, and reduce the client's discomfort.

As you shade the tattoo, the area will need to be continuously wiped so you can view your progress. Wiping without any lubricant will cause friction, leading to discomfort for the client. When the shading is complete, lightly clean the tattoo with a cool, damp cloth. This will bring some relief to the area. Apply a light anti-bacterial solution to the area. After that, place a thin coat of A & D ointment over the entire tattoo. The ointment will act as a barrier to protect the tattoo from unwanted bacteria.

CHAPTER 10

After Care

Every tattoo is considered an open wound. It is very important to treat it as you would treat any other open wound. Use thin coats of A&D ointment and bandage the tattoo lightly enough that air can still pass through.

Keep the bandage over the tattoo for at least twenty-four hours. After that, the client will need to lightly clean the tattoo everyday with anti-bacterial soap, using only their hand in a gentle circular motion. Rinse thoroughly and blot dry with a towel. Re-apply a thin coat of A&D ointment to keep the skin from drying out. Do this until the tattoo has completely healed.

Do not submerge the tattoo in water, such as taking a bath, swimming, etc., until the tattoo begins to peel.

CHAPTER 11

Frequently Asked Questions

***Why doesn't my motor power on?**

With the switch turned on, check for any loose connections. Are your batteries fresh and placed in the proper direction? Is the bottom terminal in the battery pack in place securely?

***Do I need to protect my battery pack while working?**

Protecting the pack and the wires is important. Use plastic and scotch tape to create a barrier. This should be a priority before beginning work on a client.

***How will the line work feel to my client?**

The line work is the most painful part of the tattoo. It feels as if the skin is being cut by the needle.

***How will the shade work feel to my client?**

Even though you set the depth of the needle shallower than with the line work, you are still causing trauma to the skin. Shade work feels abrasive, as if the skin is being rubbed with a scratch pad.

***What is the best way to shade?**

Always use small circles if possible.

***Why isn't my tattoo gun making visible lines?**

Are you using fresh batteries? Is the needle pocket worn out? Is your needle sharp and free of bends or kinks? Has the ink become too thick due to evaporation? (If the ink has thickened, add a few drops of water to restore it.)

***How long can I perform tattoo work on my client?**

Your client's tolerance can only be determined by the client. If you notice your client looking fatigued, stop working immediately. Make sure the client stays well hydrated throughout the entire process.

***Can I stop the tattoo and finish it another day?**

Once the tattoo begins to heal, you have to wait to resume working on the tattoo until all the prior work is fully healed.

***My client is getting blisters/welts during the tattoo process, what should I do?**

Trace all of the line work out with the tattoo gun. Wait fifteen minutes for the blisters/welts to go down and resume the process.

***Is sunlight bad for a tattoo?**

Yes. Too much exposure to sunlight will cause the ink to fade. It may also cause the ink to spread and create thick lines.

***What happens if the tattoo becomes infected?**

The client should contact a physician and seek medical attention immediately.

Lord, protect me from my friends and family; I'll take care of my enemies.

ABCDEFGHI
JKLMNOPQRS
TUVWXYZ...

. LOYALTY .

Tattoos

Printed in the United States
By Bookmasters